Mary Panzer

LEWIS
HINE
55

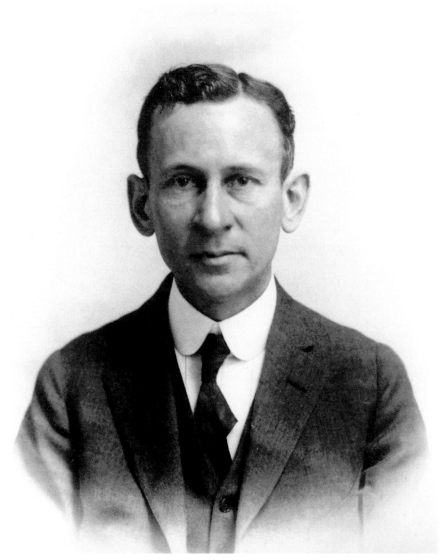

2.3

Lewis Hine, who was born in 1874, took up photography at the turn of the century as a means to an end – to call attention to social injustice, to campaign for change and to celebrate the dignity of working people in the modern world. While Hine's direct contemporary Alfred Stieglitz found little support in the art world for his belief that photographs could express the personal views of their makers, Hine never questioned the capacity of the camera to make records and also to convey emotion. His work won him wide esteem within the Progressive movement, the campaign for political, social and economic reform in the United States. Unlike Stieglitz, Hine did not exhibit his images as fine prints on the walls of galleries and museums. Instead he aimed his work at a broad public: his photographs appeared on the pages of books and magazines, in advertisements, on didactic posters, as exhibition pieces, and also as illustrations for official reports and documents. In many ways, Hine was typical of his generation in that his career took shape in response to powerful historical forces: he was inspired by the ideals of the Progressive era, he worked through the complacent, prosperous 1920s, and he suffered during the Depression of the early 1930s. Like other photographers who worked in the commercial sphere, Hine created images that were infused with his personal convictions in order to help shape public opinion. Yet he had a gift that sets his work apart. Whatever his conscious goals, Hine used his camera as a mouthpiece for the ordinary men, women and children who did not, or could not, speak for themselves.

Hine, the youngest child and only son of a Civil War veteran, grew up in Oshkosh, Wisconsin, a thriving Midwestern town. He left school at the age of sixteen to support his newly widowed mother and three sisters. For five years he held a series of unskilled jobs – working in an upholstery factory, cutting wood, delivering packages, selling from door to door – while also attending night school.

In 1895, Hine became janitor at a bank, eventually working his way up to book-keeper. His life was transformed in 1899 when he met Frank Manny, head of experimental education at the state teachers' training college, and a national leader in the Progressive movement to reform education. With Manny's help, Hine enrolled as a student at the University of Chicago, where he studied philosophy, sociology and education. Most important of all, Hine became a member of the network of philosophers, journalists, social workers, writers, teachers, lawyers and sociologists who formed the Progressive movement in Chicago.

In 1901, when Manny became Principal of the Ethical Culture School in New York City, he employed Hine to teach science. The ECS was proud of its role in developing a new philosophy of education which favoured creativity over learning by rote and strove to help students connect the subjects they learned in the classroom with the world at large. One of many articles which Hine wrote about his work at ECS, and the demands of its curriculum on teachers, indirectly provided a rare description of his own skills: 'special enthusiasm, rare patience, peculiar adaptability and a broad vision'. In 1904, continuing his search for new teaching strategies, Manny realized the value of documenting school activities and appointed Hine as the school photographer. He was given a bulky 5 x 7 view camera, a tripod, glass negatives and flash powder, and began to record classes and special events such as pageants. Manny also encouraged Hine to use his camera as an educational tool, and together they went to make photographs of the immigrants arriving at Ellis Island, the official clearing station in New York harbour. As Hine later recalled, Manny wanted his students to 'feel the same regard for ... Ellis Island that they had then for Plymouth Rock', the landing place of the seventeenth-century pilgrims who settled the British colonies in North America. He was responding to a widespread shift in the population of

the United States: since 1880 the nation had been filling with immigrants — over nine million had arrived by the turn of the century — most of whom settled in the large cities, most notably New York. While the earlier arrivals had come from England, Ireland, Scandinavia and Germany, were mostly Protestant and had some education, the immigrants that poured in between the years 1880 and 1914 came from the agricultural regions of southern and eastern Europe, were mostly Catholic and Jewish and, if they were not illiterate, knew no English. By the turn of the century, an insidious economic cycle trapped these unskilled, uneducated, immigrant populations in low-paying jobs and densely settled neighbourhoods of poor-quality, expensive housing.

The Progressives responded to this challenge in a variety of ways: the journalists with muckraking exposés of corrupt political systems or heart-rending accounts of grim conditions; the social workers by making earnest, if condescending, attempts to provide charity and instil normative middle-class values; and the sociologists who attempted to identify the structural causes of the cycle to promote change through legislation, regulation and government agencies. Hine drew inspiration from all these sources in his photographic trips to Ellis Island. He also drew on his own past experience of unskilled jobs without prospects and his great respect for work with dignity and purpose, which he believed was every person's right. With his curiosity about the everyday lives of immigrant families and children, and his great need to share his Progressive convictions, Hine used his camera to forge a new form of photographic practice.

Hine used a large camera, tripod, heavy plates and brilliant flash powder that left a smoky cloud behind. He could not work without the co-operation of his subjects and often had to solicit their participation to secure the image he

wanted. Throughout his career, Hine's work varied widely. He produced many stark portraits which show his subjects essentially as he found them. He also arranged sentimental compositions and often posed his subjects in self-conscious imitation of familiar works of art. In all cases, Hine refrained from investigating the psychology of his sitters. His approach was largely descriptive – that of a social scientist or a historian. Following common practice in sociology and social work, Hine carefully identified his subjects according to their country of origin, religion and ethnic group. His images record a wealth of information, including details of clothing, the nature and extent of a family's possessions, and individual physical characteristics such as posture and expression. But the genuine originality of Hine's approach can only be grasped through a formal analysis of his work. He consistently allowed his subjects to dominate the frame, often standing so close to his subjects that their sheer proximity allowed his images to convey information that other photographers could not capture. The faces are clear, the expressions spontaneous. Even Hine's most enlightened colleagues saw these men, women and children in a patronizing light, yet Hine's subjects look him in the eye. However transitory, this relationship between equals that distinguishes Hine's images sets him apart.

Progressive leaders made brilliant use of the popular press to promote their many causes, and Hine contributed to their campaigns. In 1906 he began working freelance for the National Consumers' League and the National Child Labor Committee, documenting the illegal work being done by children in homes, sweatshops and on the streets. In those days the school-leaving age was fourteen and, once children entered the workforce, there were no limits on working hours, no minimum wage, no safety regulations and no compensation for injury. By 1910, licensing regulations had been introduced to cover the home

production of over sixty different types of consumer goods but, as Hine's photographs showed, inspections were ineffective and working conditions shocking. Hine recorded whole families, from small children to elderly adults, gathered around tables twisting bits of wire and felt to make artificial flowers, or rolling cigars, or assembling pieces of belts, stockings or garters.

In 1907 Paul Kellogg, an eminent Progressive campaigner, hired Hine as staff photographer for an extensive sociological study of the city of Pittsburgh. The results appeared in the form of articles in *Charities and Commons*, a social work journal, and were eventually published in book form. The Pittsburgh Survey established standards for sociological investigation that came to stand for the ambitious and often moralizing style of Progressive reformers, linking economic analysis, investigative reporting and political action to create a detailed picture of working life in modern industrial society. By 1909, Kellogg's magazine became known as *The Survey* (and, later, *Survey Graphic*), and it published Hine's images and stories for the next thirty years. Around this time, Hine began to advertise his work as 'Social Photography by Lewis Hine', and under the name of 'Hine Photo Service' he issued a catalogue of his images available for reproduction in magazines and newspapers, as well as offering a range of other services – stereopticon slides, enlargements and private commissions.

In the summer of 1908, Hine left the Ethical Culture School to pursue photography full time, working both for Kellogg and for the NCLC. Over the next decade he travelled constantly, sometimes covering 30,000 miles in a single year. He stayed for several days in each area, making dozens of photographs and taking careful notes, which he used as captions and also turned into reports. The subjects of investigation varied with the season. In summer he visited agricultural

sites – strawberry fields, cranberry bogs, turnip farms and tobacco planta-
tions. In the winter he visited textile mills in the South and the Northeast,
where children helped to spin cotton and knit stockings. He went south to visit
canneries and watched children shucking oysters along the Gulf Coast. In every
city he continued to document children selling newspapers, shining shoes,
working as bicycle messengers, gleaning or stealing and living on the street.

To gain access to his subjects and their places of work, Hine assumed many
roles, posing as a roving photographer making pictures for a postcard company,
a fire inspector, a life insurance salesman, even as a reporter interested in
machines and factory construction. He used interviews with his subjects to
provide captions for the images, and identified many different motives that
led young children to work, including greedy employers, injured, missing or
negligent parents, and plain poverty. Often the children themselves sought
independence and bragged about their earning power. Through its work, the
NCLC hoped to prove that child labour was a moral disgrace and an economic
tragedy, destructive in the present and crippling to future generations. But
until its arguments could be backed up with pictures, they failed to be taken
seriously. Hine's photographs reached beyond the audience of experts and
politicians to the public at large. While legislation and regulation altered the
social landscape, it was not until the public could no longer tolerate seeing
children at work in factories, in the fields and on the streets that child labour
truly ceased. As the reformer Florence Kelley put it, 'The camera is convincing.'

Hine produced many different kinds of pictures for the NCLC which reflected his
complex assignment of reporting, record-making and propaganda. From 1913
to 1917 he was head of the NCLC exhibitions department, preparing posters

and designing elaborate storyboards to advertise the mission of the NCLC. Because the Committee had to justify its work, Hine's documents not only drew attention to problems but also demonstrated the Committee's success. Over the period of Hine's greatest work, conditions did improve. Factories grew safer and cleaner and, for the most part, ceased employing workers under the age of fourteen. But today these poignant images betray the severe limitations of the Progressives' efforts to solve large economic problems by means of legislation. Did Hine recognize how little had changed? His photographs show that factory work, though cleaner, remained grim. With his close-up style and empathetic gaze, Hine continued to document the way in which the needs of mechanical production overpowered the individuals who operated intricate machinery, turned gears, pushed levers and maintained the pace of the assembly line. This careful attention to the skilled manipulation of ever more complex tools conveyed the unstoppable momentum that, in the early years of the century, promised to continue to enlarge factories, enhance production and diminish the contribution of the individual. Whether or not the message was deliberate, some of Hine's contemporaries were able to recognize the significance of these later images. From 1911 to 1916, the *International Socialist Review* used Hine's photographs to illustrate the poor conditions to which industrial workers were subjected and called for 'one big union' to overcome the small, specialized trade organizations that divided the labour force.

In 1917, Lewis Hine, his wife Sara and five-year-old son Corydon settled in Hastings-on-Hudson, a pleasant suburb to the north of New York. After nearly ten years on the road, Hine told his colleagues in the NCLC that he wished to spend more time within reach of home. Because the Committee felt Hine's work as a writer and reporter had more value than his photographs alone, they

reduced his salary. Consequently, Hine resigned. In May 1918 he went to France to join Homer Folks, a prominent social worker and former member of the NCLC. For more than a year, Hine served as Folks's assistant, documenting Red Cross activities throughout war-torn Europe.

When Hine returned to New York in the spring of 1919, his work took a new direction. As he later explained, he wanted to make 'positive' documents as opposed to 'negative' ones. In many ways, Hine chose subjects that fitted the mood of a country enjoying new prosperity, satisfied with the social changes that had taken place before World War I. He continued to make industry his speciality, and developed a photographic genre which he called 'work portraits', documenting workers on the job. He used highly romantic language to express his goal: to celebrate 'men and women that go daily to their tasks in the great industrial structure, [who] fit into life's mosaic as interesting and highly individual units of the pattern we term "labor"'. Over the next two decades, Hine used every commission to add to his archive and, in the process, amassed a comprehensive record of industrial production in America. Among his thousands of work portraits are studies of skilled workers assembling clocks and precision tools, rubber dolls and rubber tyres, hat makers and lamp makers, the builders of airplanes, locomotives and turbines, healthcare workers, postal workers and policemen on the beat.

During these years Hine made photographs for public and private organizations that continued the work of the Progressive era, including the Red Cross in America, the Interchurch World Movement, the Milbank Memorial Fund and the Consumers' League. He also began to work for corporate clients such as Western Electric and General Electric, who used his portraits of workers in

company magazines published to improve employee relations. In addition, Hine pursued independent assignments, notably a story about the men who worked in the engines and train yards of the Pennsylvania Railroad which appeared in *Fortune*, the lavish magazine for the business elite. He maintained careful control over his work and constantly found new uses for old photographs, so that images made for one employer would appear later as advertisements for another. Though he was careful to insist that he never retouched his images, he cropped them freely and changed the titles to suit new clients.

Throughout the 1920s, Hine developed a pleasing, if highly stylized, pictorial formula which framed workers within the rounded steel arcs of gears and turbines, even though these poses often obscured or distorted the worker's actual task. However predictable they seem today, these compositions clearly satisfied the needs of Hine's clients, who frequently used this work for advertisements and promotional purposes. In the mid-1920s, his photographs appeared in several exhibitions of competition work organized by the Art Directors' Club, and in 1924 his photo-essay on the Pennsylvania Railroad received the highest award for photography. The numerous articles that appeared about Hine and his work consistently published his favourite pictures, some of which were now decades old. Few, if any, images from his NCLC years appeared. He clearly did not recognize that his sentimental celebration of lone brakemen, weathered rail-track workers or intent craftsmen had dulled people's memory of the harsh conditions he had recorded early in the century. Hine, like his audience, was not immune to the lure of nostalgia.

In 1925, he was asked to contribute photographs of workers, workplaces and families to a new textbook written by Rexford G. Tugwell, a professor at

Columbia University, and his assistant Roy E. Stryker. Tugwell and Stryker prepared *American Economic Life and the Means of Its Improvement* to introduce college students to the complex relationship between labour and capital, to promote a distinct Progressive agenda, and to argue that wealth and poverty were products of economic forces not moral imperatives. Hine's old studies of ethnic types prepared for the Pittsburgh Survey were used to represent the diversity and strength of the nation's working class. In 1933, Tugwell joined Franklin D. Roosevelt's administration and brought Stryker to Washington to help him promote new federal programmes to assist farms crippled by poverty and drought. Stryker and Tugwell understood that photographic propaganda could promote their controversial agenda, much as Hine's photographs had assisted the previous generation of reformers. Stryker hired talented young photographers including Walker Evans, Ben Shahn and Dorothea Lange in a campaign that resembled Hine's work for the NCLC in its structure and function, yet while Hine offered his services, he was never invited to join Stryker's team.

In the summer of 1930, through the help of a neighbour in Hastings, Hine became the official photographer for the Empire State Company, which broke ground that year by constructing what was to be the world's tallest office building. Planned in the booming economy of the 1920s, it appeared an outsized extravagance in the first years of the Depression. For Hine, it offered an ideal opportunity to record 'a unique album of the human side of tower construction'. Working from a special mechanical lift, Hine was able to follow the workmen up the scaffold into the sky. The thrilling views of workmen silhouetted against a vertiginous view of Manhattan streets became Hine's most popular pictures. In 1931, as he began to publish his photographs, the *New York Evening Post* called them 'a saga of the men who, outlined against the sky on dizzy heights, fuse the

iron of their nerves with the steel of the girders they build into modern cities'. With this single group of photographs Hine had achieved the goal of his work portraits — to endow labour with drama and majesty, both in the eyes of the public and in the eyes of the workers themselves. In 1932, Hine published the images of the Empire State Building with earlier favourites in a large-scale picture book, *Men at Work*. His introduction explaining his method struck a poignant personal note: 'I have toiled in many industries and associated with thousands of workers. I have brought some of them here to meet you. Some of them are heroes; all of them persons it is a privilege to know. I will take you into the heart of modern industry where machines and skyscrapers are being made, where the character of men is being put into the motors, the airplanes, the dynamos upon which the life and happiness of millions of us depend.'

With the country in depression, Hine's clients were cutting back and his correspondence makes many references to the hard times at home. In 1932 he carried out an extensive project for a display by an industrial client at the 1933 Chicago World Fair. He also worked on assignments for government agencies, photographing the farms that would be flooded by the Tennessee Valley Authority in order to construct dams and power plants, and making photographic records of projects run by the Works Progress Administration and the Public Works of Art Project. In 1936 he started working for David Weintraub, an economist whose National Research Project was investigating the way in which industrialization had changed the nature of work itself. For more than a year, Hine visited factories throughout the Northeast but the project was eventually cut short and few photographs were published. Many images from this series show older workers using antiquated machinery, as if to suggest that these men and women had lost their usefulness, much like the machines they

operated. Younger workers, using modern machines, have more energy, but no more autonomy. The partnership between Hine and Weintraub was not comfortable, and Hine complained about Weintraub's heavy editorial hand. Despite Hine's desire to celebrate his subjects, the images from this project lack the passion and confidence that informed his early work.

In 1938 Hine met the art critic Elizabeth McCausland and her close friend the photographer Berenice Abbott. McCausland wrote about Hine's work and helped to organize his first retrospective exhibition, which opened at the Riverside Museum in New York in 1939. With great energy, Hine solicited endorsements from people who had contributed to his career in large and small ways over the past four decades – including photographers Alfred Stieglitz, Edward Steichen and Hine's former student Paul Strand, as well as from Abbott, McCausland and Newhall. Roy Stryker and Rex Tugwell added their support, as did members of the Progressive community, including Homer Folks, Paul Kellogg and Frank Manny. Through Abbott and McCausland, Hine also joined the Photo League, a club where photographers gathered for classes, exhibitions, lectures and social events, and where teachers like Strand, Sid Grossman and Aaron Siskind encouraged photographers to let their political convictions guide their study of modern life.

Despite the apparent success of the retrospective exhibition and the wide acclaim he received for *Men at Work*, Hine could not hide his deepening depression. Colleagues who knew him in the 1930s remember a man who looked far older than his years. On Christmas Day, 1939, Sara Hine died after a long illness. Hine remained in Hastings with his son and his sister, but died the following November.

In 1938, curator Beaumont Newhall visited Hine in Hastings, where he spent several days going over his work, starting with his earliest photographs of immigrants on Ellis Island, and his work for the NCLC. Newhall acquired some of these early images for the Museum of Modern Art in New York and wrote several articles about Hine, citing him as a link between nineteenth-century wet-plate photographers such as Mathew Brady and contemporary artists such as Walker Evans. He recognized Hine as an artist and admired his 'straightforward, clean technique' which, in Newhall's eyes, was 'the only valid photographic style', though he acknowledged that this approach neglected the 'documentary or historical' side of Hine's achievement. But Hine never put his political goals aside in order to satisfy the world of art. On the contrary, he understood that the power of his work came from the strength of his convictions. He coined the terms 'social photography' and 'interpretive photography' to describe photographs which combine 'publicity and an appeal for public sympathy'. He learned to use camera and captions together to eliminate 'the non-essential and conflicting interests' in any photograph, to create an image that was 'often more effective than the reality would have been'. He never claimed to be objective.

As we understand the historical character of the criteria Newhall used to construct his canon of artists and images, we can also see how Hine's images stand apart from the modernist view of photographic history. Instead, his work belongs to a visual tradition that lies outside the world of the museum, in the sphere of journalism, advertising and propaganda, where pictures cannot be severed from maker or audience, a story more difficult to tell because it continues to surround us.

Young Russian Jewess on Ellis Island, New York, 1905. This young woman stands in the enormous central hall of the immigration station on Ellis Island in New York harbour, where new arrivals spent hours waiting for interviews with the officials who could approve their entry into the United States. Through the wide-arched window behind her, one could see the New York city skyline. Hine rarely published images without captions, and when he had no quote from the sitter he often borrowed verses from well-known poets. In this case, he turned to Walt Whitman: 'Inquiring, tireless, seeking what is yet unfound ... But where is what I started for, so long ago? / And why is it yet unfound?'

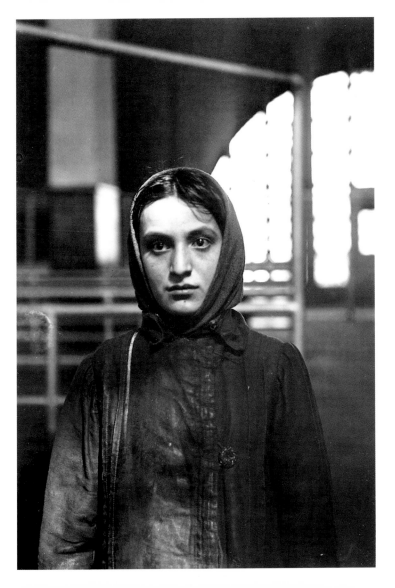

Italian Family Looking for Lost Baggage on Ellis Island, New York, 1905. Thirty years later, Hine explained his early method: 'Suppose we are elbowing our way through the mob at Ellis Island trying to stop the surge of bewildered beings oozing through the corridors, up the stairs, and all over the place, eager to get it all over and be on their way … a small group seems to have possibilities so we stop 'em and explain in pantomime that it would be lovely if they would only stick around just a moment. The rest of the human tide swirls around … we get the focus … then hoping they will stay put, get the flashlamp ready.'

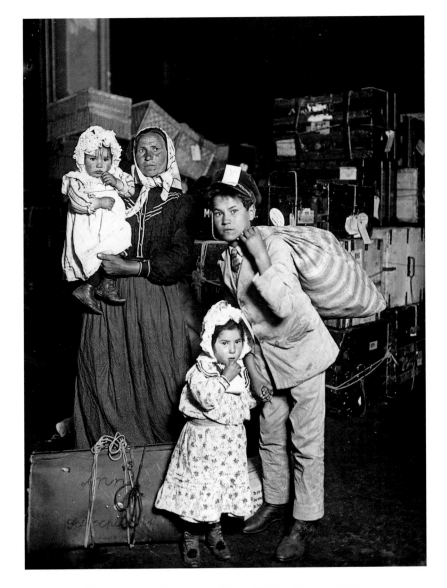

Italian Mother and Child, Ellis Island, New York, 1905. With their strange languages and unfamiliar customs, immigrants often inspired suspicion and distrust among ordinary Americans. By contrast, when Hine brought his camera to Ellis Island, he portrayed individual men, women and children, and found classic grace and dignity where others saw ugly stereotypes. Hine was also fascinated with the outer signs of ethnicity and nationality, and kept careful notes on the origins of his sitters, though, ironically, he rarely recorded their names. This image of a nameless Italian mother, with its classic subject placed in a harsh institutional setting, and a caption full of statistics, is typical of Hine's early style. His caption reads: 'This beautiful mother and child sit outside the detention cell. Sometimes 1700 immigrants were crowded into a room which was built to accommodate 600.'

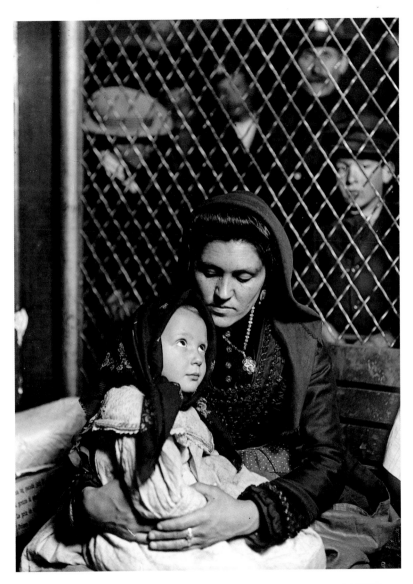

Climbing into America, Ellis Island, New York, 1905. Immigration officials watched carefully as the new arrivals climbed the steep steps to the main hall, and used chalk to mark the backs or shoulders of any who seemed weak or ill. If a medical examination revealed debilitating disease, the new arrivals never entered the country. Ellis Island also maintained hospital wards to allow children (and new mothers) to recover from temporary illness. In many cases, families stayed together, living in dormitories until all were healthy enough to pass inspection.

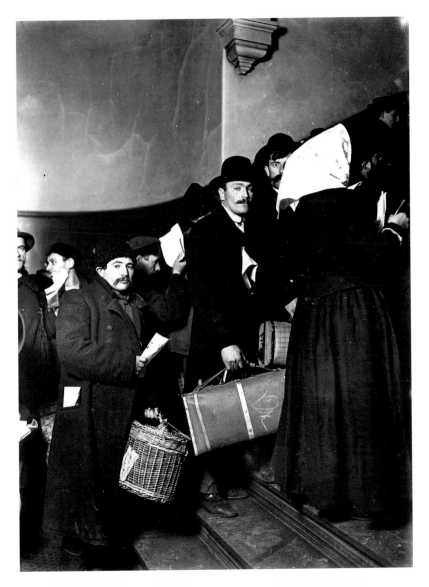

Portrait of a Boy, Pittsburgh, Pennsylvania, 1905–7. For over ten years, this boy's face appeared on posters promoting campaigns of the National Child Labor Committee. Hine contrasted his smile with the bleak faces of mill workers to illustrate the innate optimism and health that illegal labour undermined. Even the moralistic Pittsburgh Survey reported that the Slavic community cared for its children, despite poor schools and few parks or playgrounds. In formal terms, Hine's image reflects his own confidence in this child; the photographer approached the boy directly, and moved to his level, so that we stare directly into his eyes.

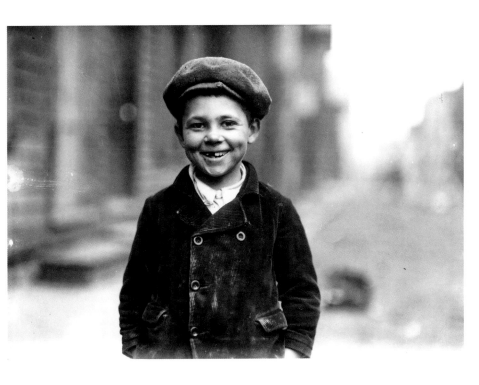

Homestead District, Pittsburgh, Pennsylvania, 1907–9. Hine gave several titles to this photograph, made for the Pittsburgh Survey: 'Steelworker in Homestead, Pennsylvania, Entertaining his Boarders after the Day's Work, 1909' and 'Out of Work, Homestead Court, 1908'. The authors of the Pittsburgh Survey viewed scenes like this with great ambivalence. When single male workers boarded with families in their already crowded tenements, surveyors saw endless 'injury to the moral tone' of the entire Slavic community. They believed doorway gatherings were more likely to encourage drunken brawls than wholesome entertainment. Yet Hine's photographs can also be seen as evidence of a cohesive community, filled with strong, dignified, hard-working men.

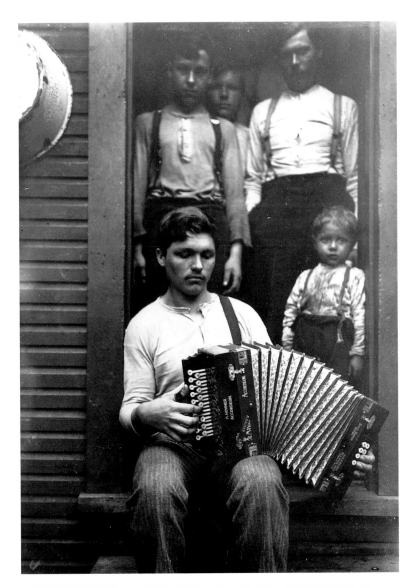

Irish Stogie Maker, Pittsburgh, Pennsylvania, 1907–10. In 1907, a study of Pittsburgh's cigar makers took the Survey from the tiny tenement workshops to large mechanized factories. In all, the cigar industry employed over 3,500 workers, and the majority were women. With heavy-handed irony, the Survey authors observed: 'The brown stogie, that symbol of fellowship, social inter-course, and the good things of the leisure hours of life, has become socially a costly thing to produce.' Here, Hine shows a typical young worker at a factory 'suction table'. By filling each mould with tobacco, the best workers produced up to 1,600 cigars a day, and earned up to $10.00 a week. But few could maintain this gruelling pace for more than a few years, and top earners were rarely over twenty years old.

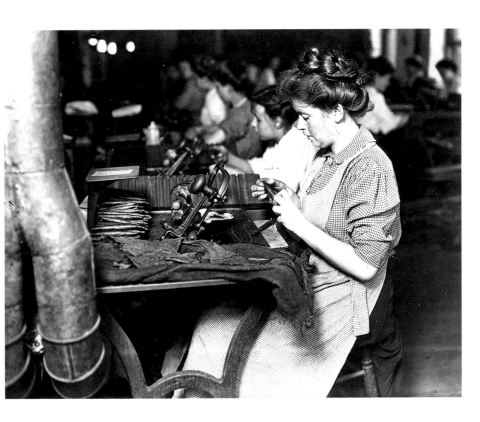

Tenement Home Work, New York, January 1908. Hine began his study of tenement home work for the National Child Labor Committee in the winter of 1908, and kept notes on the families he photographed, their work and their wages. 'Frank, 14 years, John, 11 and Lizzie, 4, work with their parents at home making artificial flowers. The father helps because his health is too poor to do other work. The boys work from Saturday afternoon and evening until 10 or 11 p.m. Lizzie separates petals. They make regularly from ten to twelve gross a week for which they are paid 6 cents a gross.'

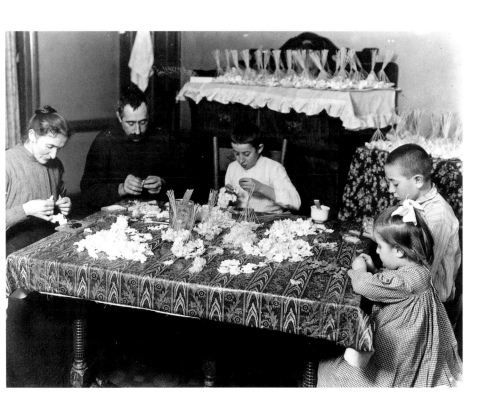

John Howell, an Indianapolis Newsboy, August 1908. On his first travelling assignment for the National Child Labor Committee, Hine accompanied investigator Edward Clopper on a five-week trip to industrial cities in the Midwest, mining towns in West Virginia and textile mills in North Carolina, and produced more than 230 images in about six weeks. In his final report, Clopper conveyed his admiration for Hine, who 'displayed both tact and resourcefulness ... and gathered a large amount of valuable material, not only photographic'. According to Hine's notes, John Howell was able to earn '$.75 some days. Begins at 6 am Sundays. (Lives at 215 West Michigan St.)'. Hine's shadow offers a glimpse of the photographer at work.

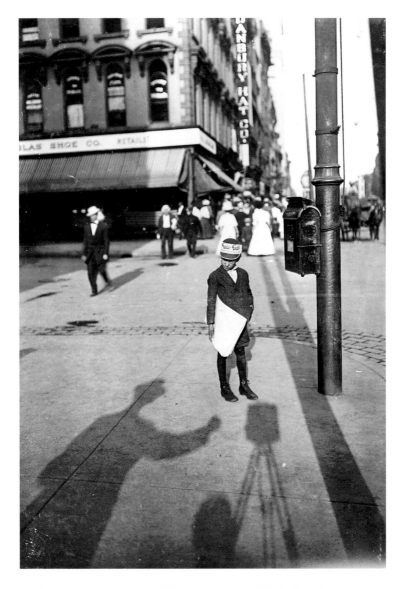

Postal Telegraph Messengers, Indianapolis, August 1908. Despite the apparent innocence of this group of boys standing before a telegraph office, this image was filled with tragedy. Because Indiana did not place any limits on the age of the messengers, Hine found many young boys working long and late, often carrying messages into areas known for crime, drugs and prostitution. Throughout his work for the NCLC, Hine frequently commented on the corrupting influence of messenger work. Yet, as commonly happens in his images of child labour, Hine's subjects clearly do not share his concerns. The resulting document provides complex historical information about the children Hine set out to photograph, and suggests his own moral outrage at their working life and the conditions that aroused this anger.

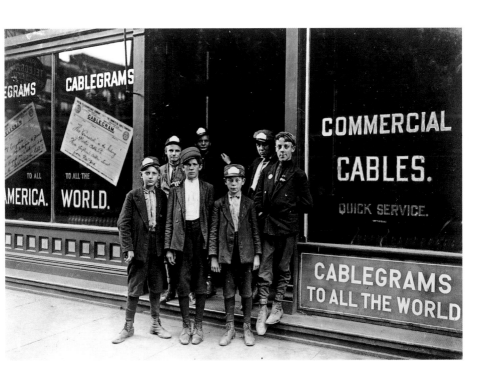

Ivey Mill, Hickory, North Carolina, November 1908. Hine understood child labour as the product of a system with many villains – indifferent parents, greedy employers, a callous industry, an ineffective legal system and an ignorant public. When Hine visited Ivey Mill, he found the three-year-old daughter of the overseer playing among the looms. He considered the presence of a little girl on the factory floor shocking, pure evidence of a degraded world that was prepared to forfeit youth and innocence to industrial profit. From images like this Hine shaped forceful propaganda and forged a blunt new vocabulary to express his views. Along with textiles, these mills produced 'human junk'.

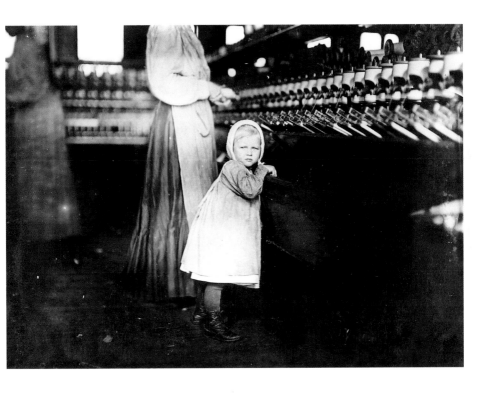

Hickory, North Carolina, November 1908. In factories throughout the South, Hine saw children producing glass, candy, clothing, furniture and tobacco, but he found the most serious violations of the child labour laws within the textile trade, and the worst conditions in North Carolina. Because of their small hands, children were often employed as 'doffers' who replaced empty spindles on the looms as they were running. 'Sweepers' kept the factory floor clean of discarded spools, threads and scraps. Where defenders of this system saw hard workers contributing to the family welfare, Hine saw children robbed of childhood, facing a bleak future. His laconic title allows the faces to speak for themselves: 'Some doffers and sweepers, plenty of them.'

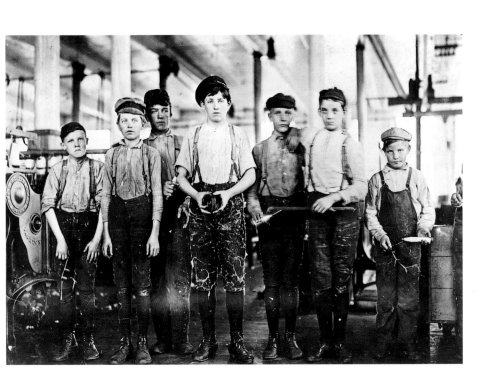

Sadie Pfeifer, Lancaster Cotton Mills, South Carolina, 30 November 1908.
Hine's caption describes a typical labourer: 'Sadie Pfeifer, 48 inches high, has worked half a year. One of the many small children at work in Lancaster Cotton Mills.' Hine noted the name, age, height and work history of his small subjects to help the NCLC prove that child labour was prevalent. Yet change could come only when bureaucrats, politicians and the public also believed it was wrong. Hine used his images in exhibits, along with strong headlines: 'Children may Escape the Cogs of the Machine but They Cannot Escape the Deadening Effect of Long Hours, Monotonous Toil, Loss of Education, Vicious Surroundings … Would You Care to Have Your Child Pay THIS Price?'

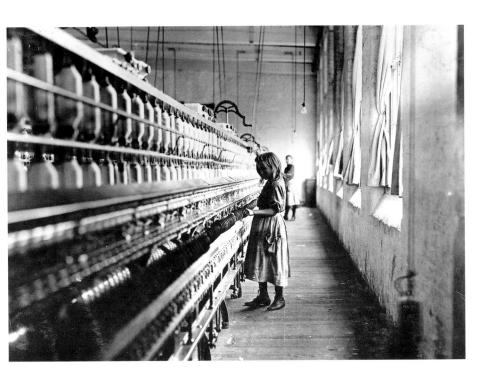

Sweeper and Doffer Boys, Lancaster Mills, South Carolina, December 1908.
Hine used the endless rows of bobbins in the spinning mill as a formal metaphor for the numbing monotony of factory work. Here he photographed an unusually co-operative employer alongside his small workers. Doffer boys watched bobbins fill with thread, and then put empty bobbins in their place. Here, the sweeper avoids the camera and while his boss stares straight ahead, he fails to enlist Hine's compassion. The result is a rare demonstration of Hine's ability to portray a man for whom he feels no sympathy.

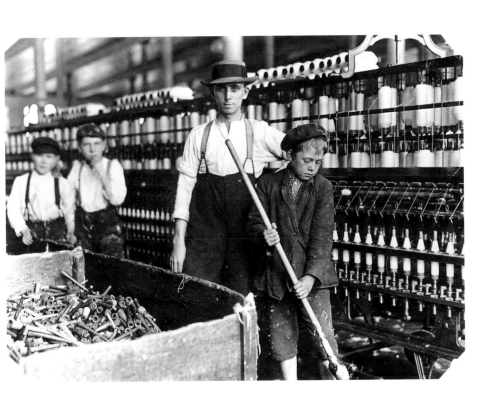

Mollahan Mill, Newberry, South Carolina, December 1908. At this mill in South Carolina, Hine recorded working conditions that were clean, light and safe, and workers who were well over the legal minimum age of fourteen. The NCLC used these images to strengthen their case by showing what good factories looked like, and to counter opponents who accused the NCLC of manufacturing evidence and ignoring the factories that had a good health and safety record.

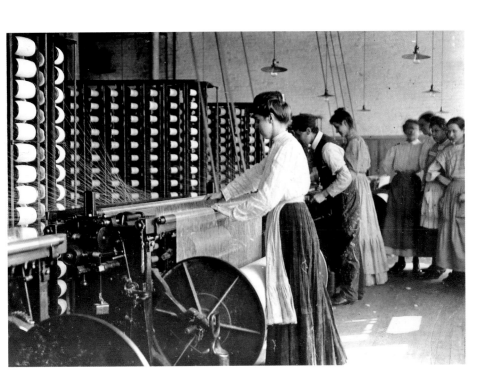

Payne Cotton Mill, Macon, Georgia, January 1909. In Georgia, Hine interviewed a one-time reformer who insisted that his state had no labour problem, then brokenly confessed that his efforts had failed. 'I worked night and day for years trying to [achieve] some kind of reform, but I had to give it up. We cannot fight the money of the mill men.' Only months before Hine arrived, legislators had failed to pass new laws restricting child labour because mill owners presented long petitions of protest all signed by the workers – mostly with an 'X'. Owners insisted that workers did not want protection: 'Let them alone. They are happy!' Here Hine photographed legal workers, 'some of them adults'.

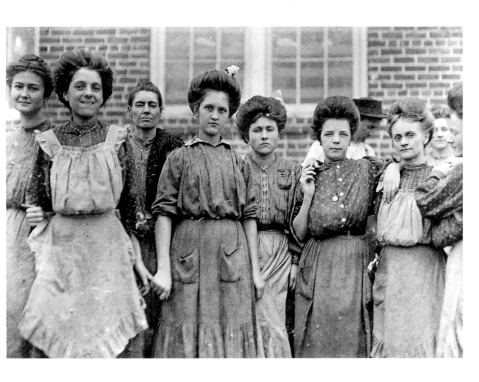

J.S. Farand Packing Company, Baltimore, Maryland, July 1909. With his colleague J.W. Magruder acting as a witness, Hine documented small boys working near dangerous canning machines. A few months later, Hine discussed his NCLC work in a lecture and compared his images favourably with advertising, which was also designed to reach a wide audience. Hine explained the success of pictures over words because a picture is 'a symbol that brings one immediately into close touch with reality ... In fact, it is often more effective than the reality ... because, in the picture, the non-essential and conflicting interests have been eliminated.' Photography also had 'an inherent attraction' because average viewers believed that 'the photograph cannot falsify'. But Hine quickly noted that 'liars may photograph'.

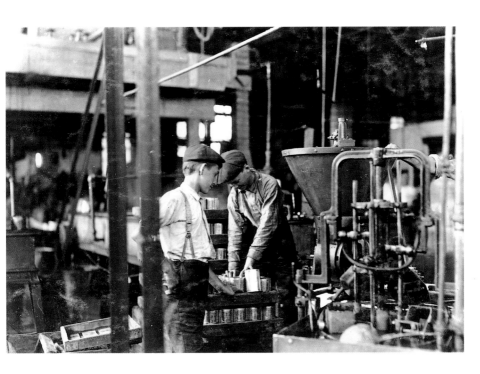

Neil Gallagher, Wilkes Barre, Pennsylvania, November 1909. By 1909 the dangers of mining were well known. In Gallagher's eyes, the story was ordinary: 'Neil Gallagher, born January 14, 1891, went to work at about 9 years. Worked about 2 years in [coal] breaker, went inside at about 11 years as a "Tripper" tending door. 83c a day. Injured May 2, 1904. Leg crushed between cars. Amputated at Mercy Hospital, Wilkes Barre ... No charge. Received nothing from company. "Was riding between cars and we aren't supposed to ride between them." No written rules but they tell you not to. A mule driver had borrowed his lamp and when he reached across to get it, he slipped between bumpers. Been working in breakers since. Same place. $1.10 a day.'

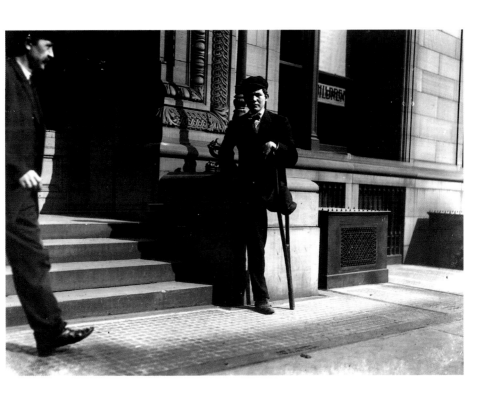

Meyer Klein, Newsie, 12 Years Old, St. Louis, Missouri, May 1910. In Hine's view, children grew in response to the world around them. Meyer Klein offered a chilling example of a life shaped by street work, a negligent family and the lure of petty crime. Though only twelve, he was often out all night, stole from department stores and rarely went to school. Two of his brothers had already been sent away to 'reform school', the juvenile alternative to jail. But while standing face to face with this hard young man, Hine managed to represent both the life that he saw and the sense that with better luck, and a more caring world, it could have been very different.

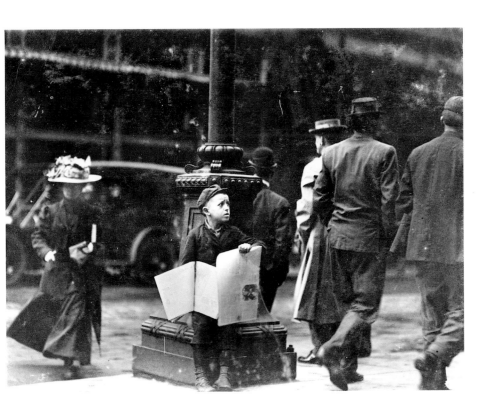

Mendicants, New York, July 1910. In the summer of 1910, while working for the National Child Labor Committee, Lewis Hine documented New York's street life for his own commercial archive. Hine made pictures of over twenty different tradesmen working from pushcarts, including a scissor grinder, a fish dealer, a street photographer, a broom vendor, a musician, vegetable sellers and their customers. In this category of images Hine also included common sights such as parading suffragettes, drunkards and this pair of professional beggars who stood at the busy intersection of 6th Avenue and 14th Street.

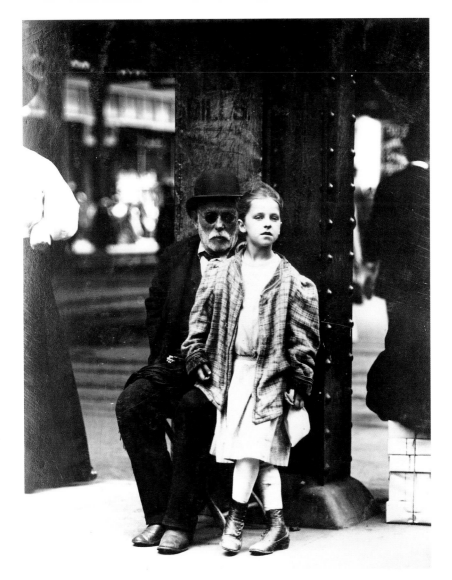

Minnie Paster, New York, July 1910. Hine's commercial catalogue included a wide variety of subjects under the category of 'Child Life', such as 'Idle children hanging around' or 'In mischief', though he consistently distinguishes between the children, who are good, and the grim conditions in which they live and work. This image of ten-year-old Minnie Paster, tending her newsstand at the corner of Bowery and Bond Streets on the Lower East Side, conveys much information about one small sector of the street economy. Hine censures the social conditions that allow this young woman to work in flagrant disregard of laws meant to protect her. Minnie Paster herself seems remarkably self-sufficient and assured.

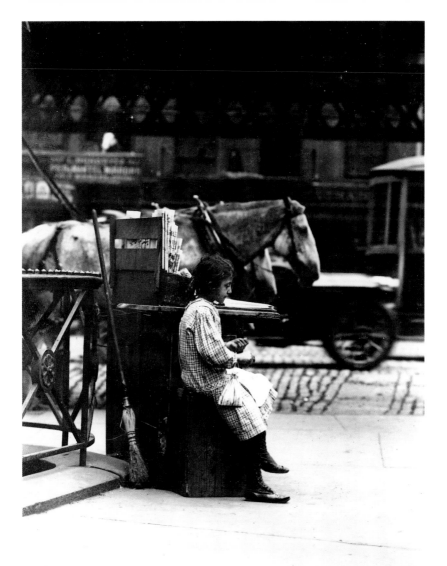

Arnac Family, Brown's Mills, New Jersey, 10 September 1910. In the summer of 1910, Hine and his partner tracked the families who travelled from urban slums to regional farms to harvest berries, vegetables and fruit. Their report described a relentless work schedule as each crop came into season. According to the report, 'the pickers worked continually for 33 days an average of ten hours per day … (no stopping on Sunday)'. But after farmers and recruiters had taken their fees, only large families could still take home a profit and children missed weeks of school as a result. The Arnacs from Philadelphia were a typical family, working alongside their children aged three, six and nine. Hine interviewed them twice: as they harvested strawberries in May, and in the cranberry bogs in late September.

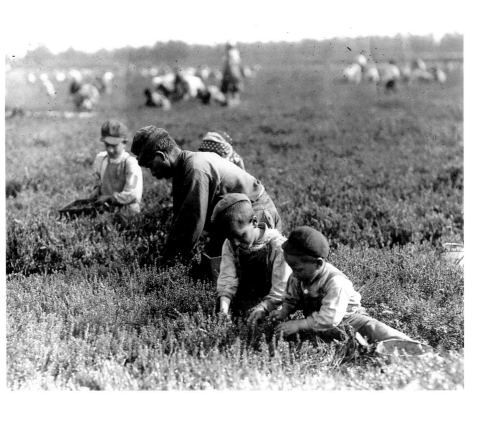

Lee, Elk Cotton Mills, Fayetteville, Tennessee, November 1910. Hine reported that Lee was eight years old, four feet tall and earned 15 cents a day picking up bobbins. With pictures and interviews like this one, Hine set out to show how it was that little children began to work in the mill. Lacking schools or any way to care for their children, mothers often brought them to work. Once in the mill, children took on simple paying jobs and gradually learned to tend the looms. When Hine asked Lee whether he was there to help his family, the boy replied, 'No, I don't help sister or mother. Just myself.' Hine called children such as Lee 'a cotton mill product' and insisted that they were created by the factories, just like bolts of cloth.

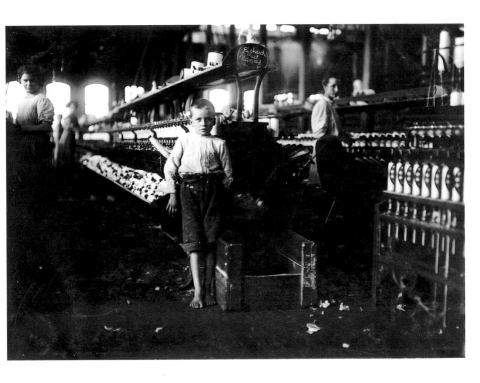

John Tidwell, A Cotton Mill Product, Avondale Mills, Birmingham, Alabama, November 1910. When Hine visited the Avondale Mills, he introduced himself to the foreman as a postcard salesman looking for subjects, and agreed to wait while official approval was sought from the manager, son of the state governor, who also owned the mill. Once the foreman was gone, Hine went around to the back of the mill and photographed the children at work, returning to interview the manager after he had taken his pictures. The governor's son discouraged him from photographing the dirty, unattractive children, then explained that he was suspicious of photographers, who were 'getting material for an anti-cotton-mill crusade'.

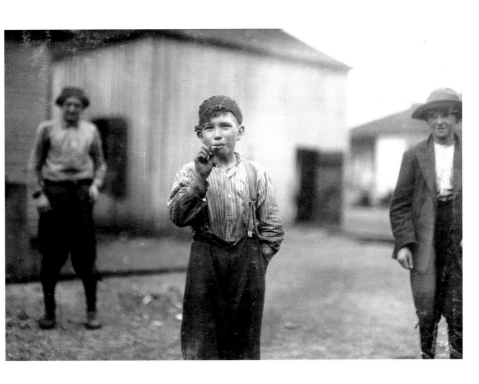

Loudon, Tennessee, December 1910. 'This little girl, like many others in this state, is so small she has to stand on a box to reach her machine. She is regularly employed as a knitter in Loudon Hosiery Mills.' Hine found hosiery mills better work sites than the cotton mills nearby. In general, the workers seemed healthier and the wages were higher. In one factory town, he described well-built mills, well-kept grounds, attractive company houses, schools and churches. But once inside the mill he saw dozens of children working in the spinning rooms. All were trained to answer his questions, claiming to be fourteen no matter what age they were. 'Surely I thought not a thing neglected, except the children.'

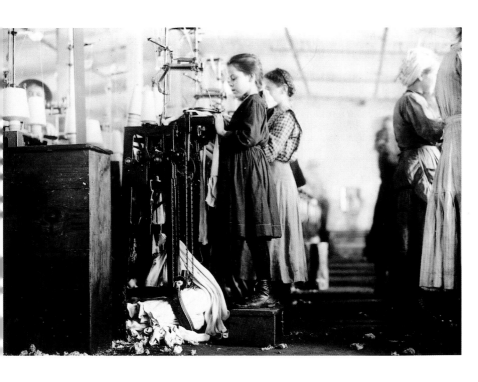

A Streetwalker, New York, 1910. Around the time this photograph was made, Hine published a catalogue of his 'Social and Industrial Photographs' to solicit commercial orders for lantern slides or reproductions. Hine divided his inventory into topical sets, and gave each image a number according to set and subject matter. After customers identified their interests, Hine mailed out sample images which they then returned with their orders. In examining a rare surviving catalogue the author discovered many new subjects in Hine's inventory, including a set devoted to 'Prostitution', which included images of brothels, commercial signs for midwives (who also performed abortions) and this picture of a streetwalker.

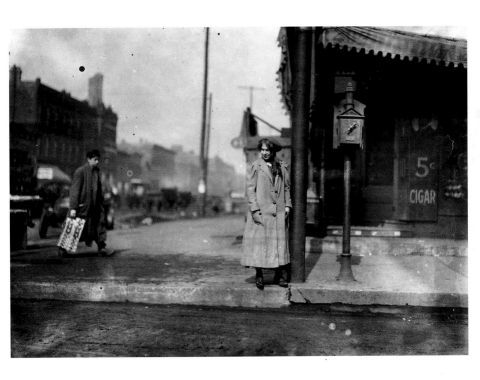

Group of Oyster Shuckers in Baltimore Canning Company, Maryland, February 1911. At the Baltimore Canning Company in the winter of 1911, Hine saw many mothers bring their children with them to the sheds during the ten-hour shifts. In interviews, mothers and their children — such as five-year-old Gertrude Kohn and her eight-year-old sister Paulina — proudly described the many pints of shucked oysters they produced, and Hine noted their stoic indifference to the sharp shells that cut their hands and the brine that rotted their shoes. The NCLC records preserved a newspaper account of the then president's visit to a similar oyster shed full of child workers. President Wilson never crossed the threshold, repelled by the darkness of the shed, the bitter cold and the foul stench of rotting fish.

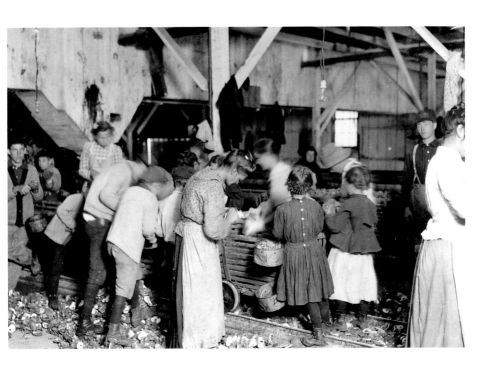

Feathermaking, New York, April 1911. Like many progressive organizations, the Consumers' League hoped to end injustice through education. To illustrate the League's study of the millinery trade, Hine took his camera to factories, sweatshops and salesrooms, and revealed an elaborate economy of sweated labour that produced the fashionable hats worn by women of all classes. Here workers are 'selecting, preparing, willowing, curling' plumes. These factories also produced great profits. Workers commonly earned less than a dollar for nearly two days' work needed to produce an 18-inch feather, while retail shops sold that same feather for about $25.00.

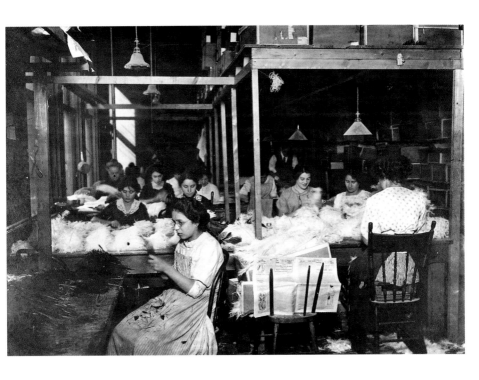

Strawberry Farm, Massachusetts, Summer 1911. In 1910 and 1911 Hine and his fellow investigators documented the conditions on the farms where families came to work the harvest. Hine and his partner found '900 workers, 400 of whom are children, living in 17 shacks, 52 people to a house'. A bog owner explained, 'We figure a foot per person. They ... live like pigs in [the city] and we give them nothing better than they have all year round.' To those who agreed that children were better off on farms than in factories, Hine and the NCLC were able to show that this labour hardly resembled chores on a family farm. This little boy apparently works alone to fill a tray with boxes of strawberries. His trays will be added to the family total at the end of the day.

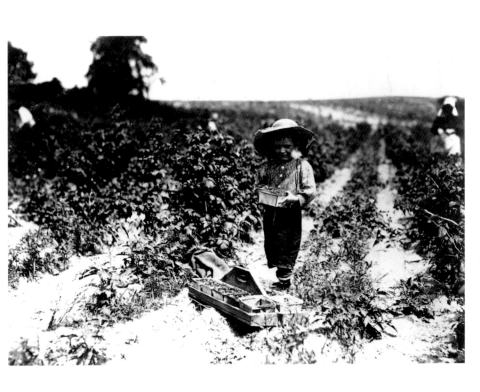

Lacemakers, New York, December 1911. 'Home work' was a special target of the National Child Labor Committee, and Hine entered hundreds of tenements to photograph families gathered around tables to make a wide variety of goods. These photographs then appeared on posters denouncing the many interconnected factors which kept this system in place: 'Home work destroys family life, keeps the child from school, allows greedy manufacturers and parents to make a mockery of childhood. Would you like your child to grow up here?' Hine shows Mrs Palontona and her thirteen-year-old daughter Michaelina making 'pillow lace'. Before he left, the daughter sold Hine the lace she was working on.

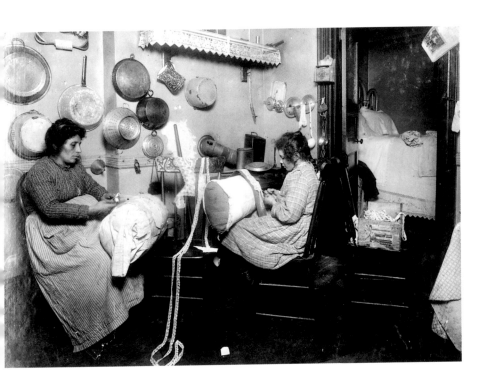

Noon Hour in the Coal Breaker, South Pittston, Pennsylvania, 1911. Early in January 1911, Hine photographed the young workers in the coal mines of eastern Pennsylvania. In his visit to Shaft 7 of the Pennsylvania Coal Company, he was given the superintendent's official letter congratulating the district foreman on getting through two months without a fatal accident. (A few days later an explosion in a nearby mine shaft ended this record.) Hine found that school principals, probation officers and miners 'universally' agreed that the coal breaker was the most dangerous place in the mine to work. At the Coroner's Office, the statistics showed that more deaths occurred among breaker-boys than inside the mine.

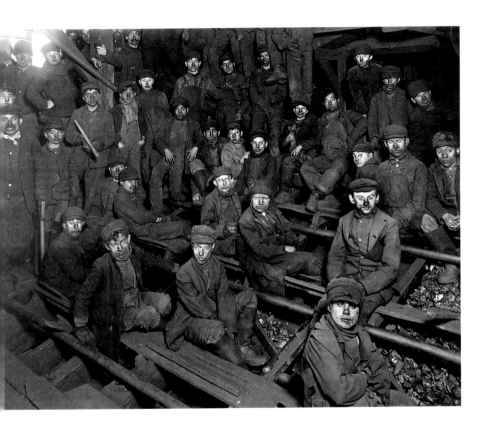

Shelling Nuts, New York, December 1911. For the Consumers' League, Hine visited tenements where families took in 'home work' to expose a dense network of manufacturers, jobbers and workers who produced food, toys and clothing that transmitted disease, including tuberculosis, to affluent consumers. 'Mrs Mary Rena is shelling nuts. Two neighbors are helping. The girl is cracking nuts with her teeth. Not an uncommon sight. Mr Rena works on a dock.' Images appeared with forceful captions: 'The mother has no time to care for home or children ... The consumptive father or mother often picks fruit, or nuts ... Some results: Diseases are spread ... by the things you eat, raisins, nuts, currants, prunes ... Do you imagine you are safe? Where does your merchant buy [his wares]? Ask him – then ask us!'

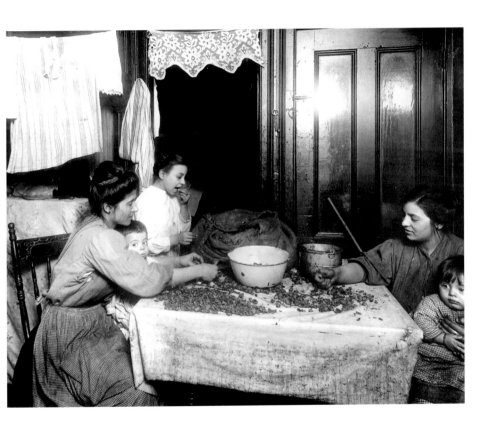

Sanders Cotton Manufacturing Company, Bessemer City, North Carolina, October 1912. In an NCLC report, Hine described a typical accident and its aftermath. Twelve-year-old Giles Newsom had been working for over three months when a piece of machinery dropped on to his foot and crushed it. Then he fell into the unprotected gears of a spinning machine, mangling his hand and tearing out two fingers. When Newsom's father learned that his son would receive compensation, he tried to bargain with the company. Newsom's mother blamed her son because he got the job by his own efforts. His aunt said, 'He's jest got to where he could ... help his ma, an' then this happens and he can't never work no more like he oughter.'

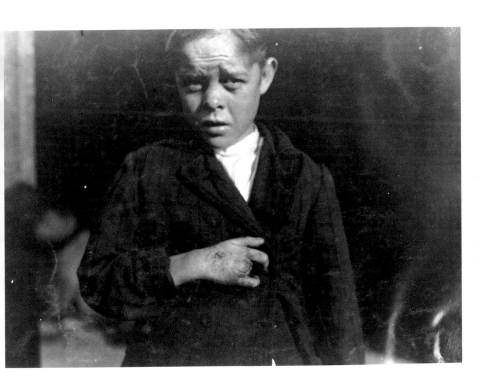

Rear of Republican Street, Providence, Rhode Island, November 1912. In preparation for the Child Welfare Exhibition of 1912–13, Hine documented housing for mill workers in Providence. Hine stood above this sunken yard to photograph a group of tenants in a crowded slum, and his head and shoulders cast a slightly ominous shadow over the centre of the lower edge of the picture. While the image clearly represents a space cluttered with laundry and rubbish, it is also filled with clues that convey a sense of hope: the bright shapes of clean linen, the youthfulness of his subjects, the baby in her father's arms all suggest the presence of some nurturing spirit, and a future that could be better than the present.

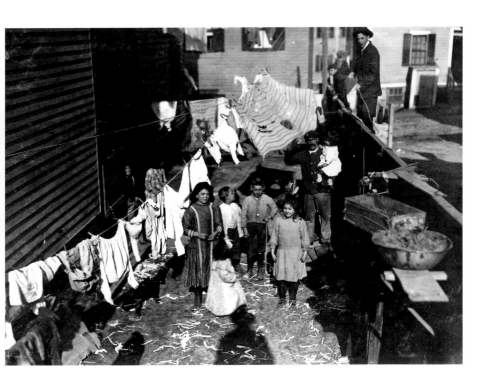

Olneyville, Providence, Rhode Island, 1912–13. In November 1912, Hine photographed both the exteriors and interiors of tenements which mill owners provided for their workers. Hine's captions note the nationality of the workers, the size of the rooms and the rent they were charged. 'Overcrowded home of workers in cotton mill ... Eight persons live in these 3 small rooms, 3 of them are boarders. Inner bedrooms are 9 x 8 feet, the largest room 12 x 12 feet ... Polish people. Property owned by the mill, rent $4.50 a month.' Hine used statistics to tell his story about immigrant workers who could never earn enough to live in middle-class comfort. Yet by rendering the household inventory so completely, the photograph is lent a sympathy that the judgmental caption lacks.

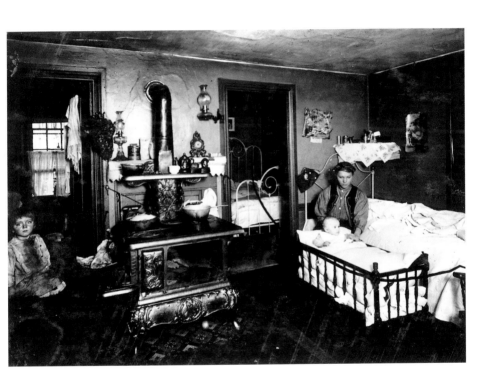

Dinner Toters Waiting for the Gate to Open, Eagle and Phoenix Mill, Columbus, Georgia, April 1913. In Columbus, Hine came across a system whereby small children entered factories carrying meals to workers. Once inside, they often stayed to tend machines while the workers ate. With characteristic empathy for his subjects, Hine captured the energetic spirits of these young girls, not mentioned in the caption. 'This [system] is carried on more in Columbus than in any other city I know, and by smaller children ... Many of them are paid by the week for doing it, and carry sometimes 10 or more a day. They go around the mill ... help tend to the machines ... and learn the work. A teacher told me mothers expect the children to learn this way, long before they are of proper age.'

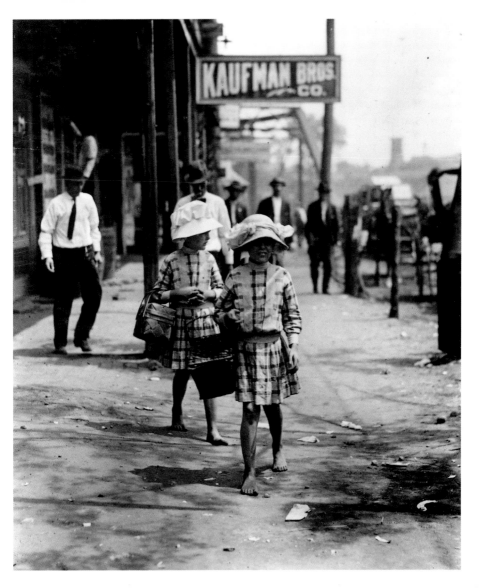

Willie Cheatham, 16 Years Old, Western Union Messenger Boy, Montgomery, Alabama, October 1914. Hine strongly believed that messenger-work led his subjects directly to crime, with irreversible consequences. In this interview, Cheatham confirmed all Hine's worst suspicions, bragging, 'You bet I know every crooked house in town. Went to school with one of those girls when she was straight. Her mother died and she went bad ... I go out to Red Light some days with messages and packages. And if I want to, I bust right in and sit down.' Was he exaggerating his corruption to shock his listeners? Hine noted his 'hard face'.

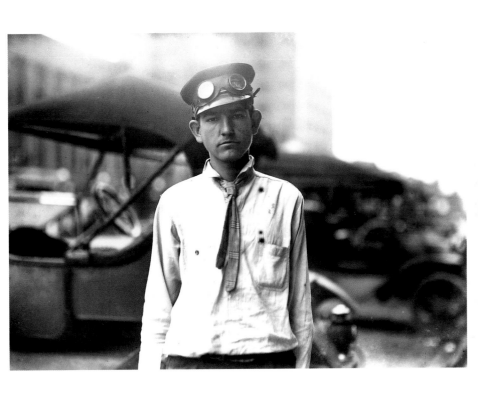

Mollie Steuben, 10 Years Old, Topping Beets near Sterling, Colorado, July 1915.
At the start of World War I, Hine and the NCLC began to discuss ways to treat immigrant children as 'future American citizens'. In Colorado, Hine observed the consequences brought on by the social isolation of rural immigrant families. With little stake in their adopted country, he observed that 'their standards of honesty are low and their respect for our laws and practices is almost nil'. Local officials suggested that schools could provide the remedy, by teaching 'the fundamentals of American life … This is the only posssible solution if we expect these people to become a part of our civilization rather than an indigestible lump within the body politic.'

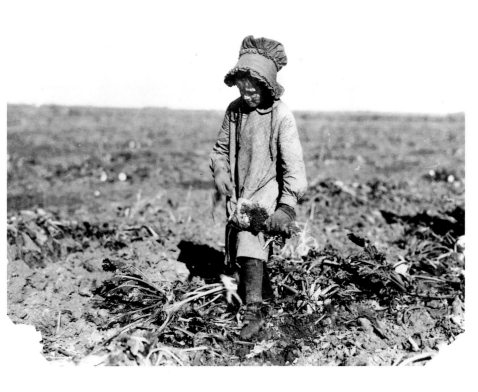

Bertha Bonneau, 15 Years Old, King Philip Mill, Fall River, Massachusetts, July 1916. After nearly a decade of using the medium of photography to change labour conditions, remove children from the workplace and promote health and safety in the factory, Hine sometimes recorded evidence of successful reforms. In 1916, on a visit to the mills of Fall River, Hine found clean, orderly factories and mature workers. As a doffer, Bertha Bonneau worked on a spinning machine which twisted cotton into thread and wound it on to bobbins. When the bobbins were filled, she replaced them with empty ones. This dangerous job was once given to children but new machines and new regulations now made it safe work, undertaken by adults.

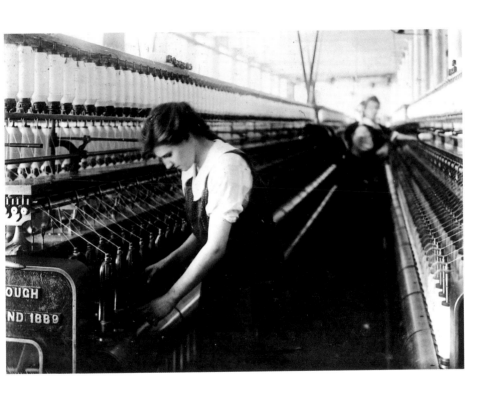

Another Madonna, Europe, 1918. In June 1918, Hine went to Paris where, together with a number of Progressive colleagues, he joined the American Red Cross. He travelled across Europe documenting programmes sponsored by the Bureau of Refugees and Relief to provide aid for refugees, the wounded and the many children in need of shelter and medical care. Along with images designed for fundraising, Hine recorded the people in the street who had always been his favourite subjects, including this mother and child. According to his caption, he felt this image fell short: 'I didn't catch it this time. Wind and cold and spectators proved too much distraction.'

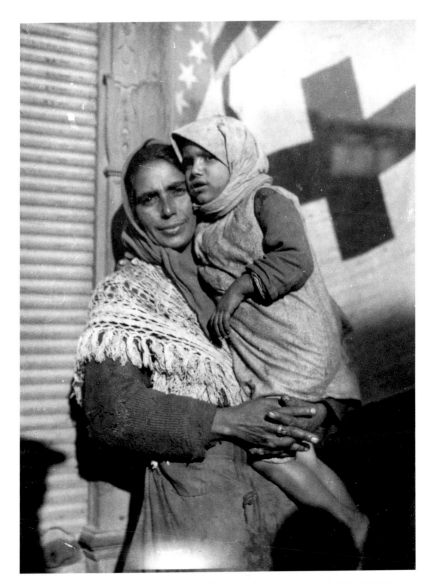

Toulouse, France, 73 Years Old, 1918. In the summer and autumn of 1918, Hine toured northern France, recording typical faces and old-fashioned customs. These picturesque images mark the beginning of a new style and a new point of view. They suggest the origins of a philosophical shift that he later explained in a much-quoted phrase. 'In Paris, after the Armistice, I thought I had done my share of negative documentation. I wanted to do something positive.'

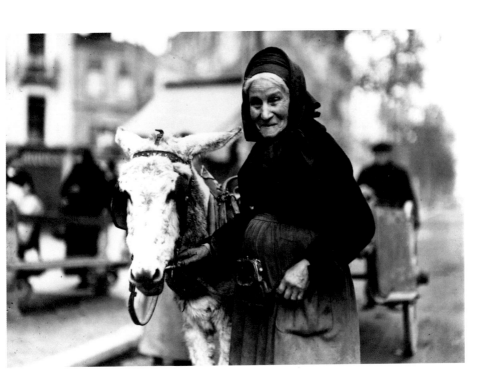

Mechanic at Steam Pump in Electric Powerhouse, 1920. In the 1920s, as Hine began to work for commercial clients, he adopted a less critical approach to the subject of labour, which he named 'interpretive photography'. This image, now one of his best known, demonstrates the features of the new style, including the composition that became a cliché – or a signature – of his work in the 1920s. A worker (usually male) poses in profile against a background of steel, framed by a rounded shape often found in power generators. Hine classified these photographs in several overlapping categories, including 'Powerhouses', 'Machines' and 'Labor'. Over the course of the decade, Hine also revived these images with a single, abstract title: 'An Industrial Design'.

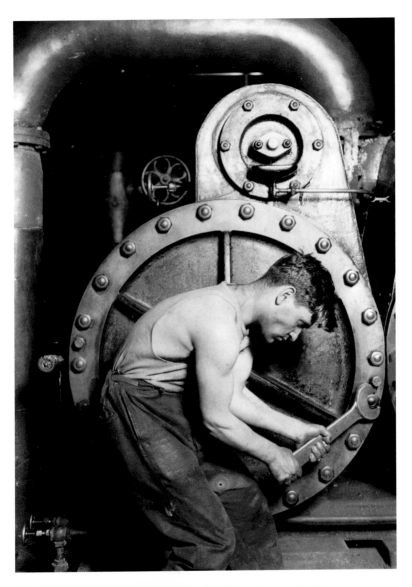

An Expert Linotyper, 1920. In the years after World War I, Hine worked for several social welfare agencies, including the Interchurch World Movement, active for only a few years after 1918. The historically black American Methodist Episcopal Church was one of many organized religious groups that joined this ecumenical union. In 1920, Hine conducted a thorough survey for the IWM, documenting, in his words, 'the life and achievements of the Negro, North & South'. This portrait of a young linotype operator was one of many that showed how African-Americans had successfully entered the modern workforce.

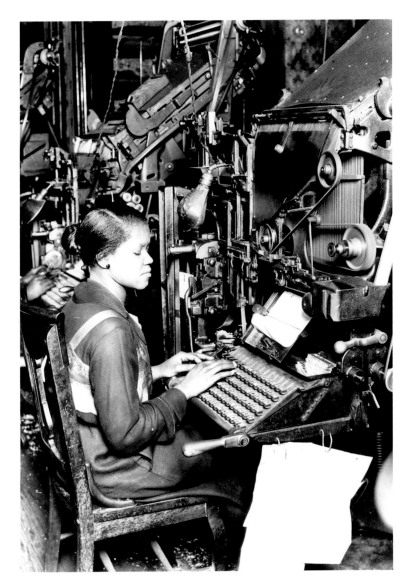

Student at a Machine Bench, 1920. Hine's documentation of African-American life included a tour of the many historically black colleges, supported in part by the Board of Education for Negroes, an agency within the Methodist Episcopal Church. In 1920, the Board began a campaign to raise funds for these schools, which included teachers' training colleges, theological seminaries, technical training schools and schools for physicians, surgeons and nurses. These were located throughout the South, where laws prohibited black and white students from attending the same institutions. Hine identified this image of a black male student as part of the 'Southern Negro' series commissioned by the Interchurch World Movement.

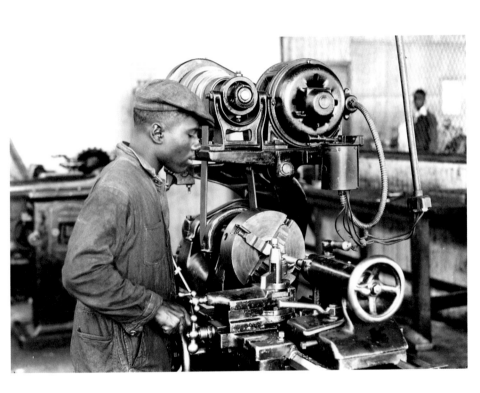

Jo – Italian Track Walker on Pennsylvania Railroad, near New York, 1920. Hine published this image in 'The Railroaders: Work Portraits', which appeared in *The Survey* in October 1921. This series of photographs began the project which he pursued for the rest of his career. In December, *The Survey* published a second group, entitled 'The Powermakers'; other essays followed sporadically, including 'New Truckmen', 'Harbor Workers' and 'Postal Service in the Big City'.

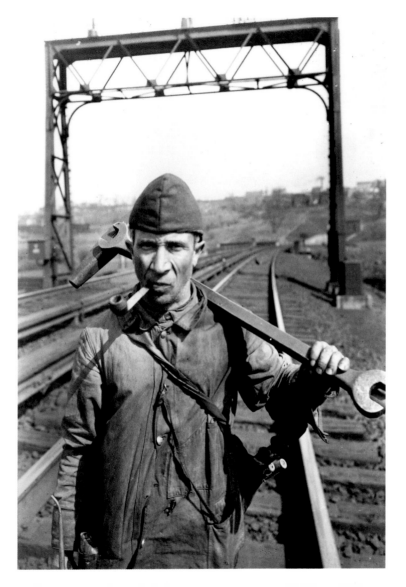

Milbank Memorial Fund Project, Cattaraugus City, New York, 1926. The Milbank Memorial Fund, one of the oldest philanthropic foundations in New York, used its massive resources to improve public health. In 1923, with the support of the Yale School of Public Health, the Fund set up three experimental clinics, one each for rural communities, medium-sized cities and metropolitan neighbourhoods. The rural programme, located in Cattaraugus City, was established primarily to detect, treat and prevent the spread of tuberculosis, and to provide health education in public schools. Lewis Hine's photographs documented the programme and illustrated the final official report, 'Health on the Farm and in the Village', which appeared in 1931.

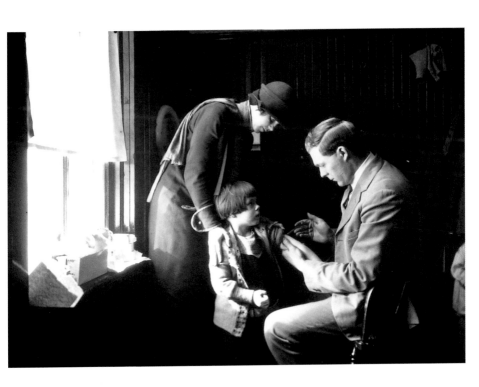

Man at Dynamo, 'General Electric' Series, c.1930. Throughout the 1920s, as Hine took on commercial and industrial clients, he found many opportunities to return to the subject of man's relationship to industry and power, reworking his signature composition of a labourer posed within the steely halo of a machine. As he told one interviewer, he deliberately sought to combine sociology with art in order to 'show the meaning of the worker's task, its effect upon him and the character of his relation to the industry by which he learns his living'. Many of Hine's contemporaries viewed his work as a fresh contribution to the wide-spread movement in modern art to represent 'the human problem of men and women in modern industry'.

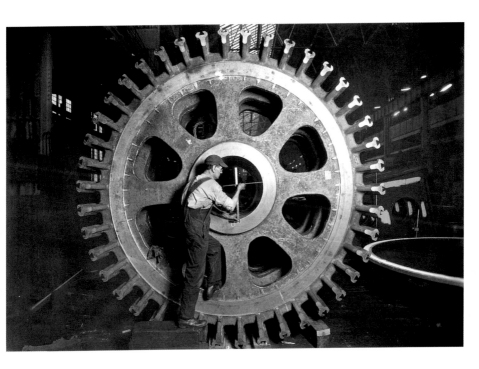

Worker Pulling on Rope, Empire State Building, New York, 1931. As official photographer for the company that constructed the Empire State Building in 1930 and 1931, Hine followed the process from the lower floors to the very highest level. Making records of the many building tradesmen at work, Hine revealed a dazzling combination of modernity, industry and romance and produced some of the most important pictures of his career. As the project came to an end, he told an interviewer, 'These experiences have given me a new zest of high adventure, and, perhaps, a different note in pictorial interpretation of industry.'

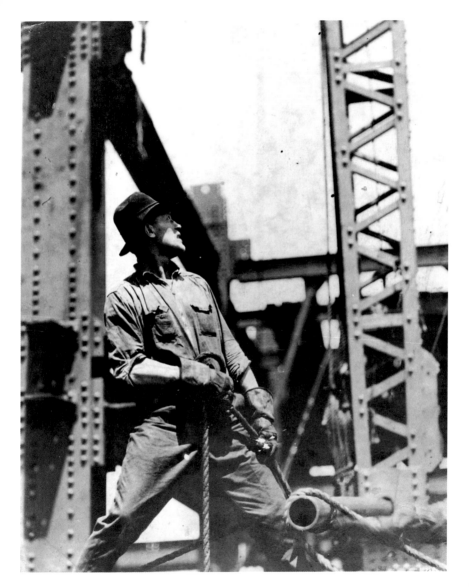

Worker Hanging on to Two Steel Beams, Empire State Building, New York, 1931.
Hine's glorious images of the Empire State Building successfully conveyed the
courage and dignity of the men he photographed, but the actual work they per-
formed was almost always impossible to see or understand. This dramatic image
shows a 'safety man' who was responsible for keeping the worksite free of loose
boards, neglected wires and forgotten tools. 'He safeguards the workers and
the people below in the street,' Hine explained in a caption.

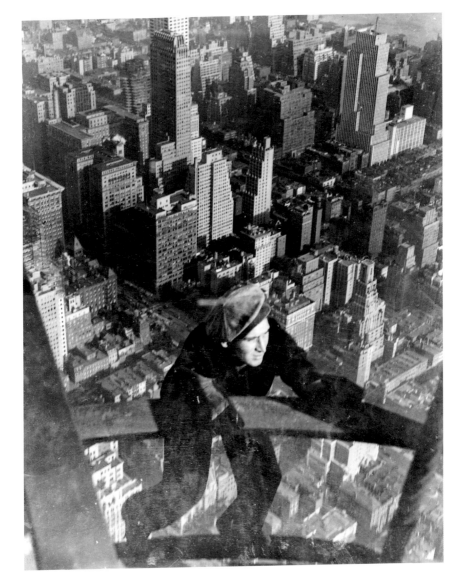

Icarus, High Up on Empire State Building, New York, 1931. With characteristic subtlety, Hine gave an ironic edge to this image when he provided a title that invoked the myth of a soaring young boy as well as his tragic end. This became one of the best-known pictures in Hine's most famous series. His photographs of the Empire State Building workers turned individual men into a series of iconic figures, defined by their power, their physical beauty and their immense courage. While Hine insisted that he was motivated by portraiture, that he was 'most of all interested in the actual human beings', he also explained that ultimately he strove to capture something very abstract, 'the spirit of the skyscraper'.

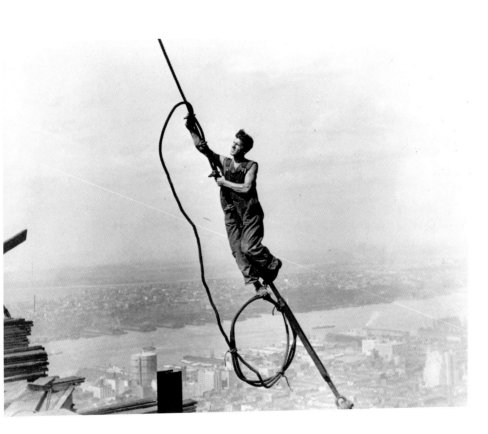

Josephine Borgess, *Western Electric News*, 1932. Hine began working for the Western Electric company in 1923, providing illustrations for the magazine it distributed to over 61,000 workers in order to promote loyalty, productivity and a sense of 'community' within the company. In the late 1920s, Western Electric became a pioneer in the field of 'employee relations', working in conjunction with the Harvard Business School to prove that workers were much more productive when they felt significant and recognized – a philosophy that fitted well with Hine's own vision. As Hine told one interviewer, he sought to make images that would show, 'both to the workers and the managers, a picture record of the significance of industrial processes and of the people engaged in them'.

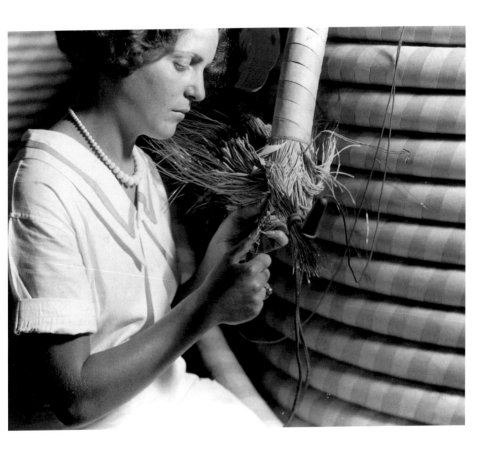

Tyre Workers, Pennsylvania Rubber Company, 1936–7. Hine photographed the Pennsylvania Rubber Company while serving as chief photographer for the National Research Project of the Works Progress Administration, a vast government agency that employed thousands of citizens during the Depression. Though it ultimately failed to revive the economy, the projects undertaken by the WPA enhanced public life in many ways, such as providing murals for new federal buildings, improving facilities in national parks, publishing travel guides and supporting sociological research, including that of the NRP, which studied innovation in industry and its effect on labour. Hine called this 'the most glorious visual joyride I've had since the old days of Child Laboring and Red Crossing'.

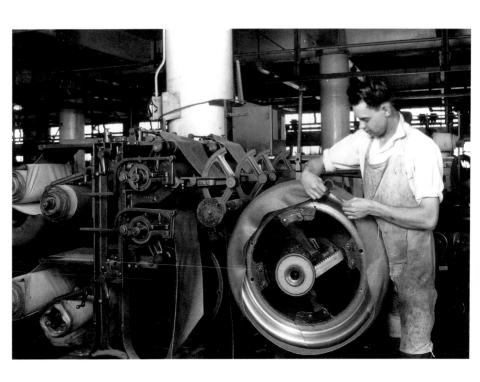

Inspecting Barrel Bridges in Hamilton Watch Factory, Lancaster, Pennsylvania, 1937. When photographing inside the Hamilton Watch Factory for the National Research Project, Hine found many opportunities to show how modern technology still could not replace individual skill and training. In this photograph of a woman inspecting tiny machine-tooled watch parts, Hine implicitly emphasized the value of longevity and experience in the workforce.

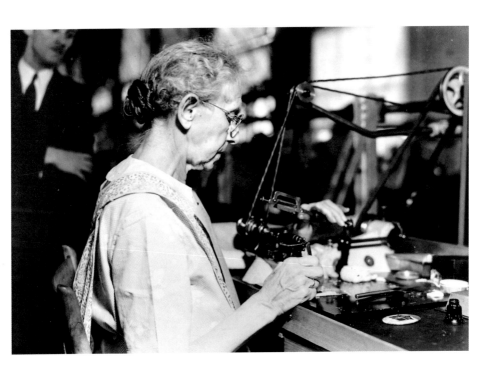

Twisting in a New England Silk Mill, 1937. At the beginning of the NRP project, Hine wrote happily to his friend Paul Kellogg, 'The range of their needs is great and I have in the past delved into about every kind of thing they are calling for, from industrial technics to social welfare.' But by the project's end Hine had clashed with its director, David Weintraub. While Hine hoped to document a wide array of subjects, which he called 'Manpower–Skills–Change', Weintraub, a sociologist, was more interested in images that would illustrate his research report.

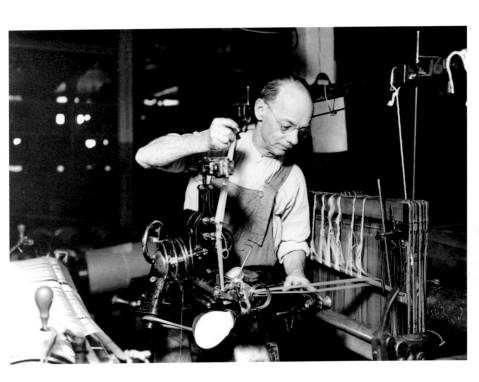

Portrait of an Engineer, Pennsylvania, c.1940. The last image Hine published in his lifetime appeared in *Camera Annual* of 1940, a lavish photography magazine edited by Edward Steichen. Only five years apart in age, the two photographers shared Midwestern roots, a capacity for hard work and the intense desire to reach a wide public. That Hine, at sixty-four, was an old man is evident from the fact that he chose to submit a conservative image and to bypass the intense, child labour pictures of his early career and his sophisticated views of the Empire State Building. This pleasing image of an old, confident engineer recalls Hine's dedication to the working man. The next generation would rediscover Hine's unique talent and his storytelling pictures that combined anger, sorrow and compassion.

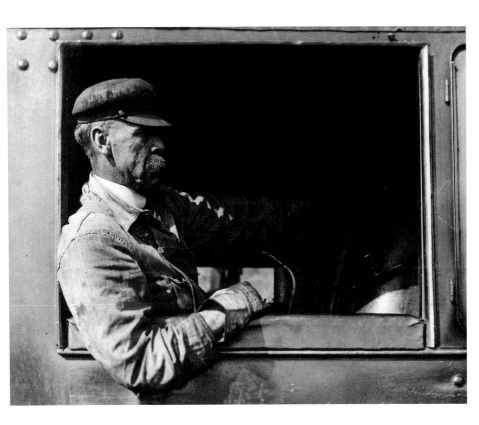

1874 Born 26 September in Oshkosh, Wisconsin.

1890 Hine's father dies. Hine begins work in an upholstery factory.

1893 Factory closes. Hine takes various unskilled jobs. Studies stenography and bookkeeping at night school.

1895 Joins bank as a janitor, eventually promoted to clerk.

1899 Meets Frank Manny, head of experimental education at State Normal School. Hine is admitted as a student, and begins formal training as a teacher.

1900 Hine moves to Chicago to study philosophy, sociology and elementary education. Meets leaders of Progressive community.

1901 Frank Manny, now Principal of the Ethical Culture School in New York, invites Hine to join the faculty as a science teacher.

1904 Appointed school photographer. Hine first takes his camera to Ellis Island to photograph newly arrived immigrants. Marries Sara Rich, a teacher from Oshkosh. Meets members of the New York Progressive community.

1906 Begins selling photographs to Paul Kellogg, editor of *Charities and Commons*. Starts work for the National Consumers' League and freelancing for the National Child Labor Committee.

1907 Becomes staff photographer for the Pittsburgh Survey, a large sociological study of the industrial city and its workers.

1908 Leaves Ethical Culture School to work full time as photographer and public educator. Becomes staff photographer for *Charities and Commons*, now renamed *The Survey*. Joins staff of the National Child Labor Committee as field investigator and photographer.

1908–1910 Hine's photographs for the NCLC appear in the popular press, illustrating articles on labour and reform efforts. Travels extensively throughout the US. Also works as publicist, lecturer, lobbyist and

writer. Advertises freelance services as 'Lewis Hine, Social Photography', and runs Hine Photo Service, selling images for publication.

1912 His son, Corydon Wickes Hine, is born.

1918 Resigns from the NCLC. In May, joins social worker Homer Folks in France as part of an American Red Cross team assisting refugees. Travels to Italy, Greece and Balkans to document Red Cross activities.

1919 Returns to New York, begins a new, 'positive' style of documentary photography. These 'work portraits' remain a concern for the rest of his career.

1919–1930 Continues to work for Red Cross in America, National Child Labor Committee and other social welfare organizations. Takes on industrial clients, including the Western Electric Company and General Electric, who publish Hine's photographs in internal magazines for employees.

1924 Receives medal for photography from the Art Directors' Club.

1925 Contributes illustrations to *American Economic Life and the Means of Its Improvement*.

1930–1931 Documents construction of the Empire State Building.

1932 Publishes *Men at Work*, a picture book devoted to the representation of industrial labour.

1933–1937 Works for various US government agencies.

1938 Beaumont Newhall acquires Hine's work for the Museum of Modern Art, New York. Newhall, Elizabeth McCausland and others publish profiles of Hine and his career.

1939 Retrospective exhibition of Hine's work at the Riverside Gallery, New York. Joins the Photo League, a club devoted to teaching and exhibiting documentary photography. His wife, Sara, dies after a protracted illness.

1940 On 4 November, having undergone surgery, Hine dies.

Photography is the visual medium of the modern world. As a means of recording, and as an art form in its own right, it pervades our lives and shapes our perceptions.

55 is a new series of beautifully produced, pocket-sized books that acknowledge and celebrate all styles and all aspects of photography.

Just as Penguin books found a new market for fiction in the 1930s, so, at the start of a new century, Phaidon **55**s, accessible to everyone, will reach a new, visually aware contemporary audience. Each volume of 128 pages focuses on the life's work of an individual master and contains an informative introduction and 55 key works accompanied by extended captions.

As part of an ongoing program, each **55** offers a story of modern life.

Lewis Hine (1874–1940) took up photography to call attention to social injustice and to campaign for change. This respect for the exploited and oppressed individual established him as an embodiment of American values. His images celebrated the dignity of working people in the modern world and gave a voice to the ordinary men, women and children who did not, or could not, speak for themselves.

Mary Panzer is a historian with a special interest in American photography. She was Curator of Photographs at the National Portrait Gallery, Smithsonian Institution, in Washington DC from 1992 to 2000.

Phaidon Press Limited
Regent's Wharf
All Saints Street
London N1 9PA

Phaidon Press Inc.
180 Varick Street
New York NY 10014

www.phaidon.com

First published 2002
©2002 Phaidon Press Limited

ISBN 0 7148 4197 8

Designed by Julia Hasting
Printed in Hong Kong

Photographs by permission of the Library of Congress, Washington DC, New York Public Library and George Eastman House, New York.